THE ESCAPIST'S

HarperCollins books may be purchased for educational, business,
or sales promotional use. For information please e-mail the
Special Markets Department at SPsales@harpercollins.com.

First published in 2016 by
Harper Design,
An Imprint of HarperCollins*Publishers*
195 Broadway
New York, NY 10007
Tel: (212) 207-7000
Fax: (855) 746-6023
harperdesign@harpercollins.com
www.hc.com

This edition distributed throughout North America by:
HarperCollins*Publishers*
195 Broadway
New York, NY 10007

ISBN 978-0-06-257361-2

First Printing, 2016

Printed and bound in China

THE ESCAPIST'S

DOT — TO — DOT

EXTRAORDINARY NATURE

Connect the dots. Unveil a masterpiece.

HARPER
DESIGN

An Imprint of HarperCollinsPublishers

HOW TO USE
THIS BOOK

Dot-to-dots were a requisite of childhood; a simple puzzle that kept us quiet for a few moments while we excitedly uncovered the scenes within them. It is this philosophy that runs throughout the Escapist series, with each image offering a short sojourn from the stresses of your day, allowing you to slow everything down and lose yourself in those few moments when your focus is devoted solely to satisfyingly watching a picture take form through the lines you draw.

Each puzzle within this book will take 10 to 20 minutes to complete, and needs nothing more than your pen or pencil of choice to get going. Here are some extra tips and ideas to think about along the way:

- Look for the triangle (▲) to start.

- Opt for a thin pen over thick, such as a fine felt tip, and choose one that doesn't smudge easily.

- If you can't find the next number, try not to rush ahead. Look farther afield to the left, right, up and down.

- Don't worry about making mistakes; extra lines add texture!

- Experiment with your creations. Why not use a colored pencil to connect the dots, add shading or color in the pictures once finished?

- For a printable key with all of the completed illustrations, please visit hc.com/naturekey.

However you choose to bring your images to life, we hope they prove a satisfying and creative time-out from your day. Enjoy!

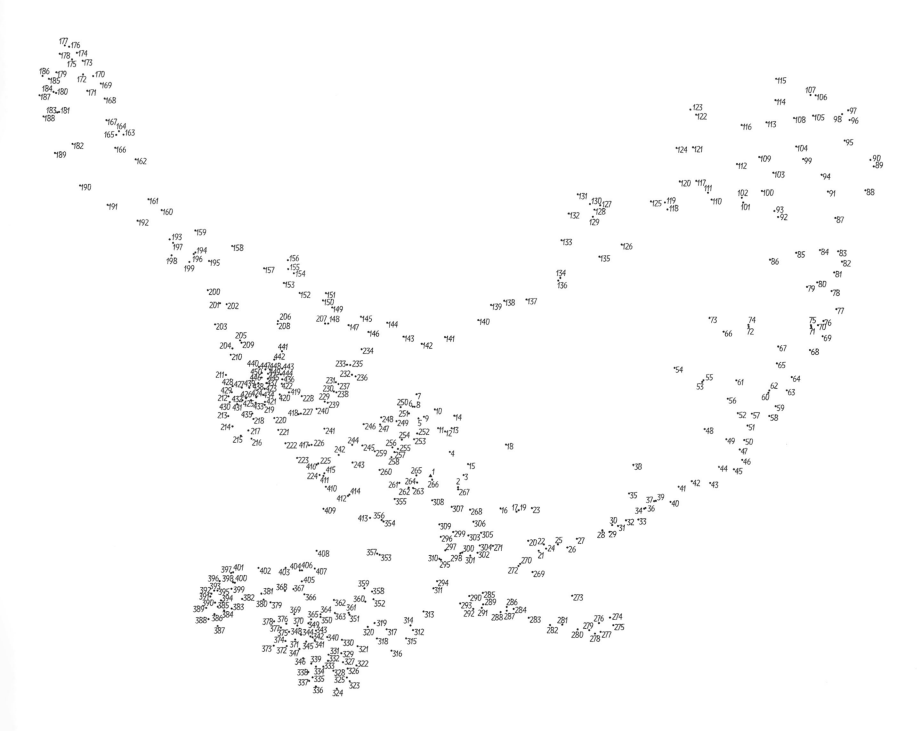

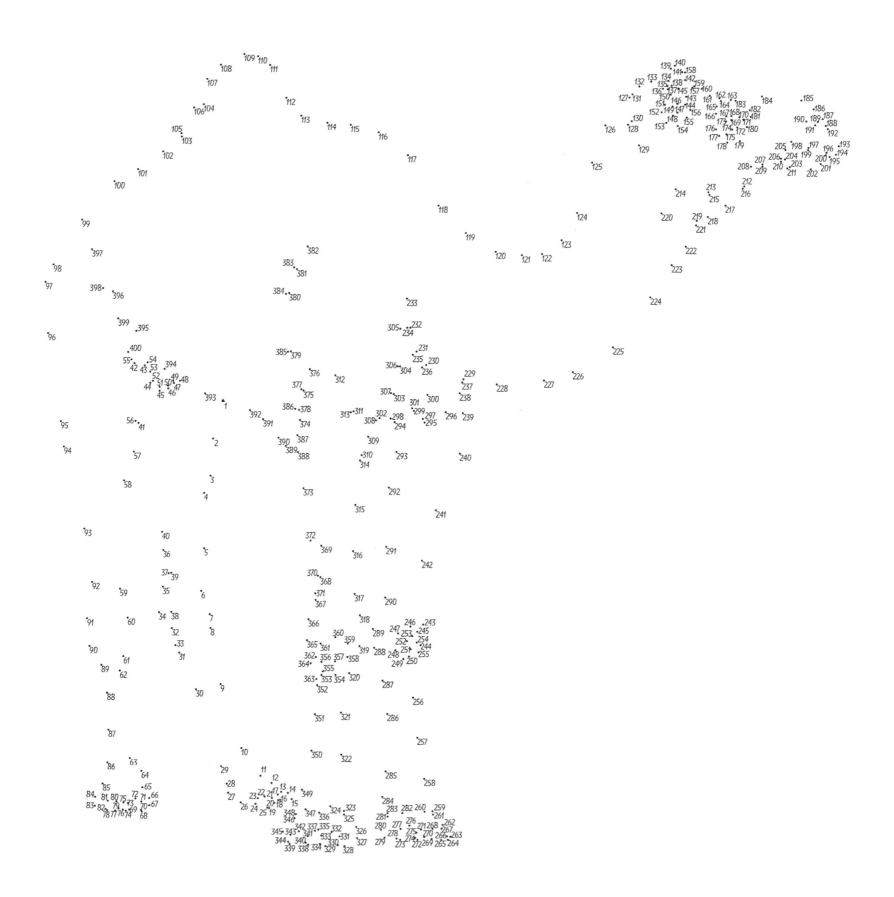

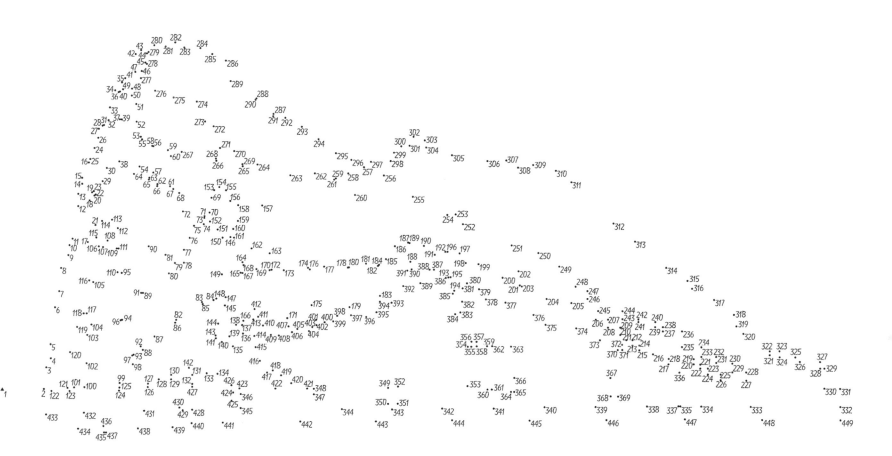

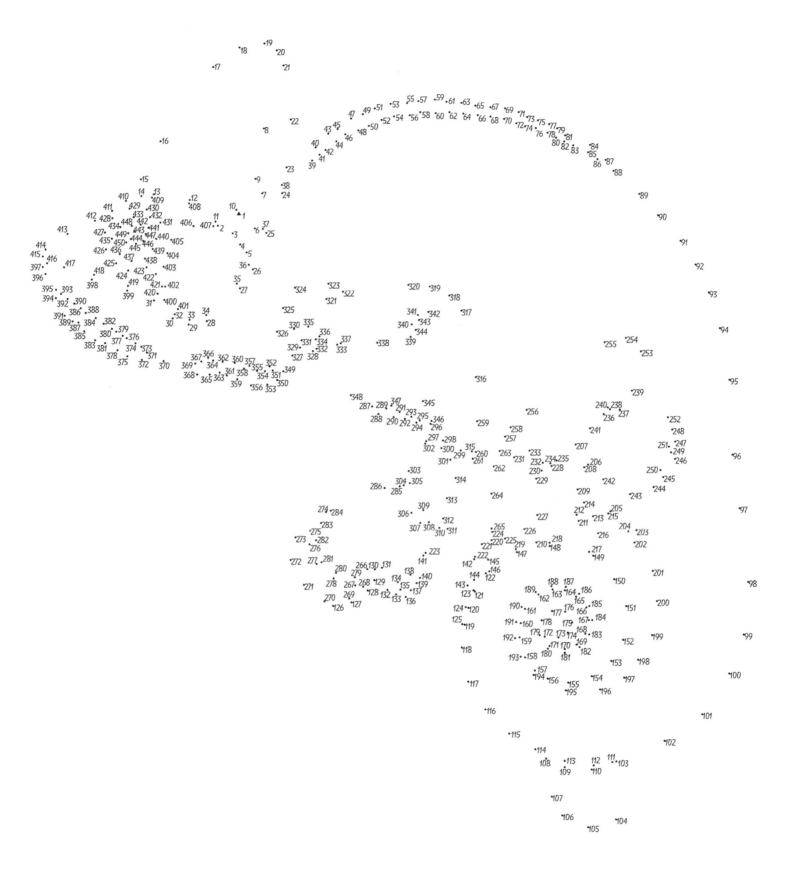

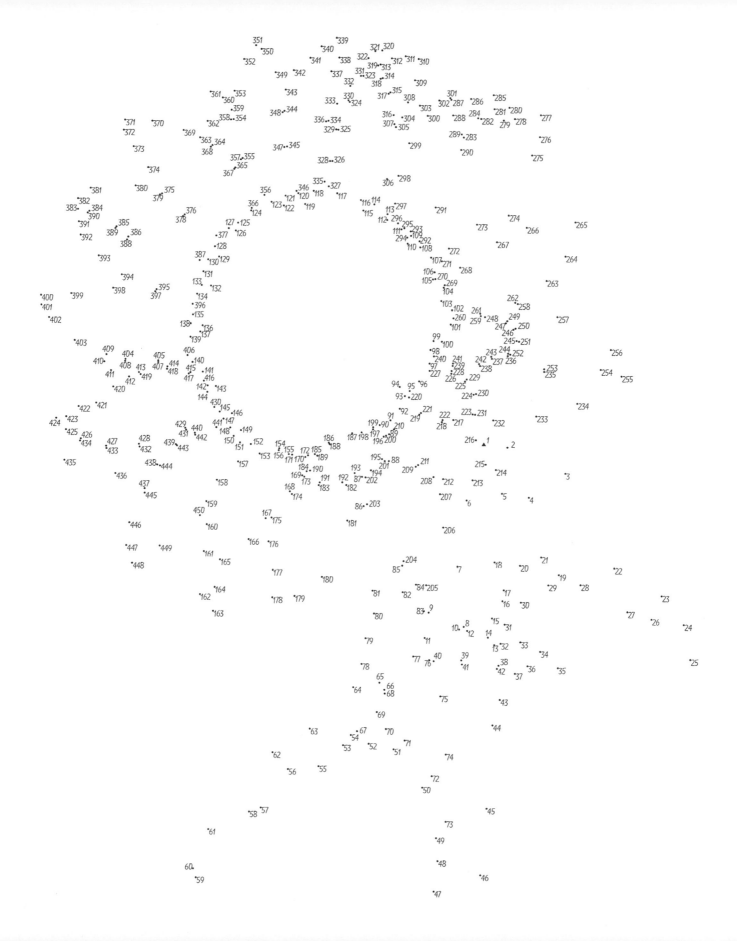

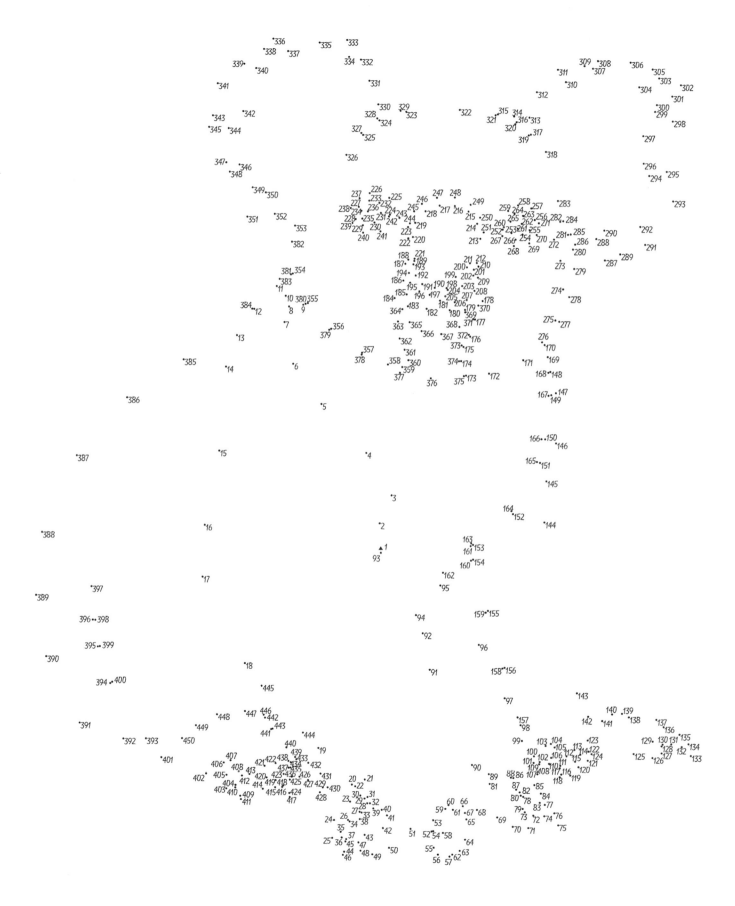

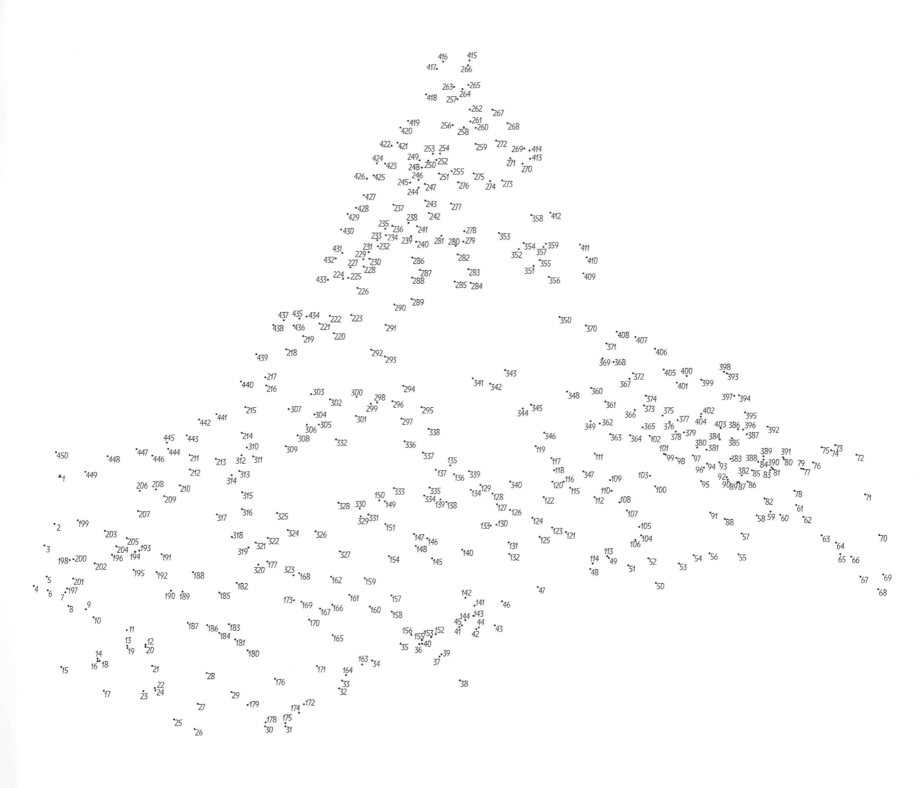

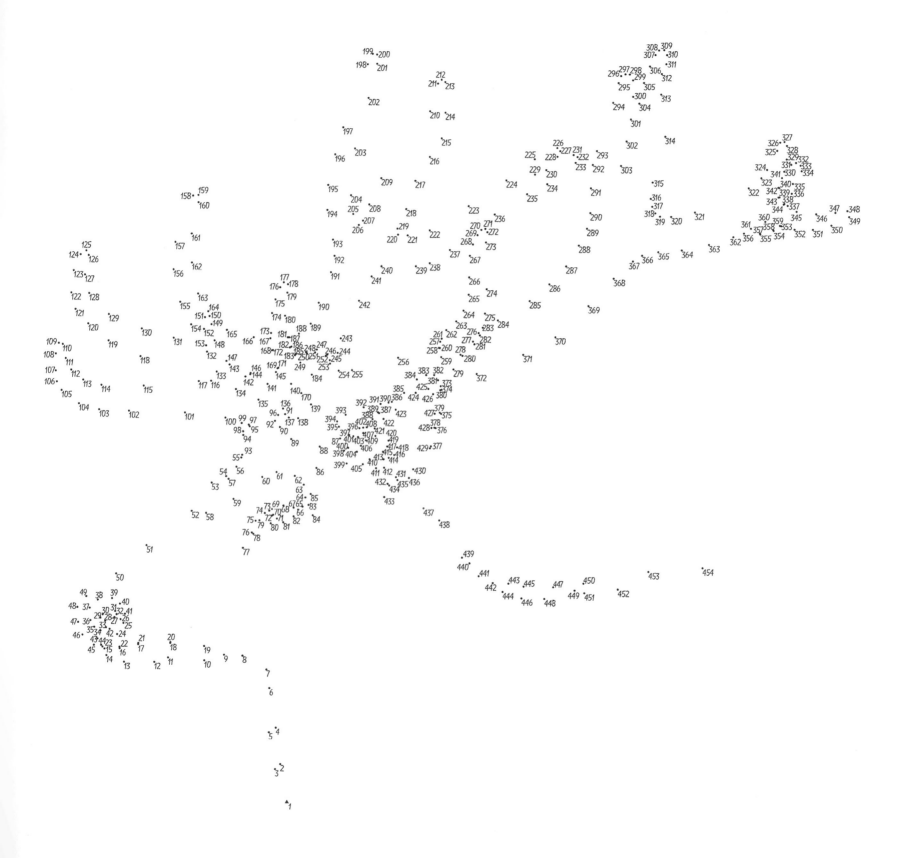

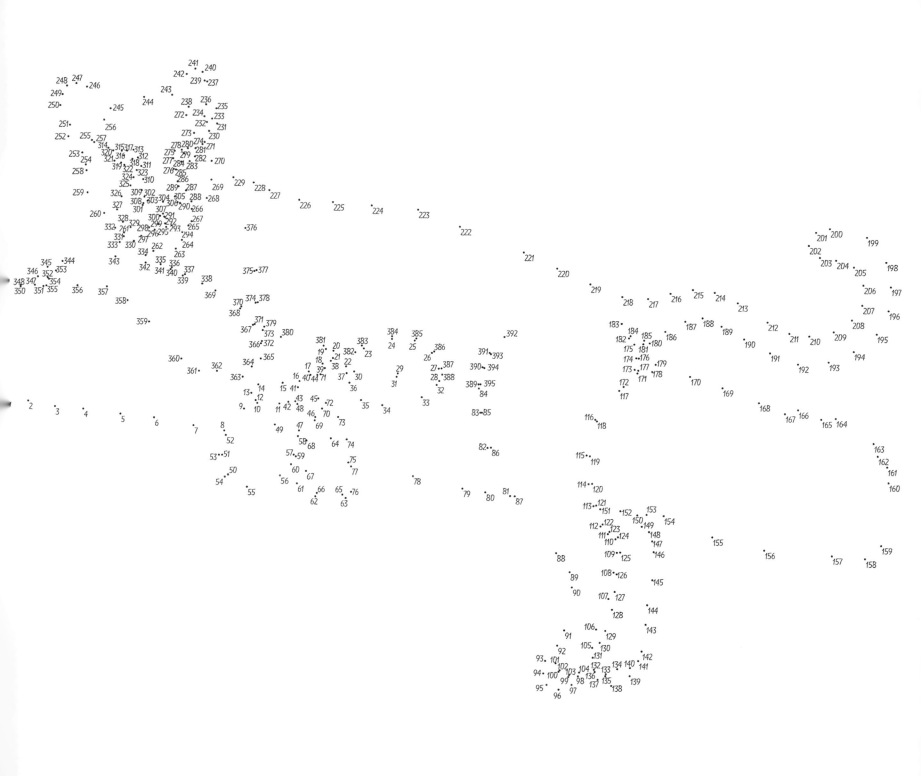

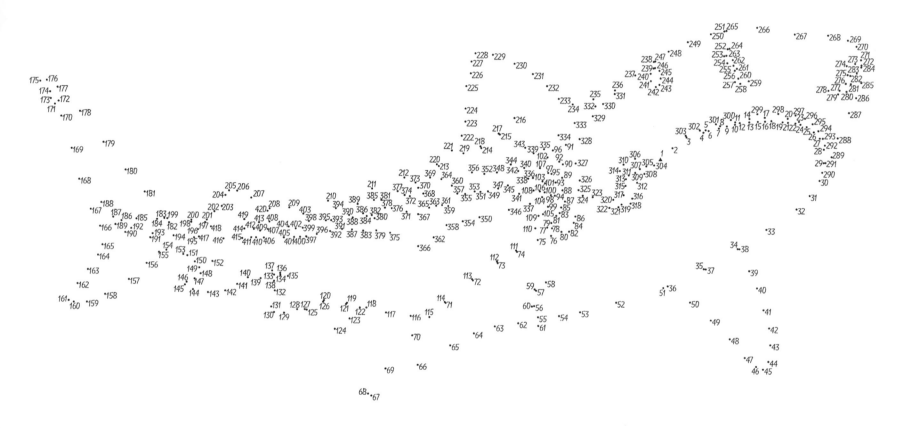

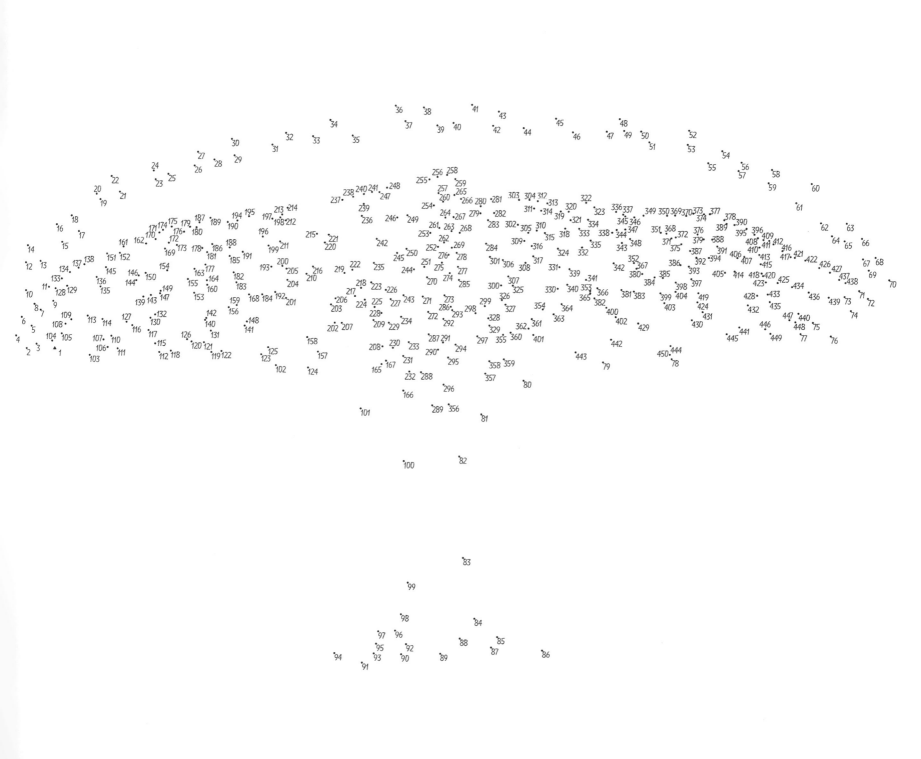

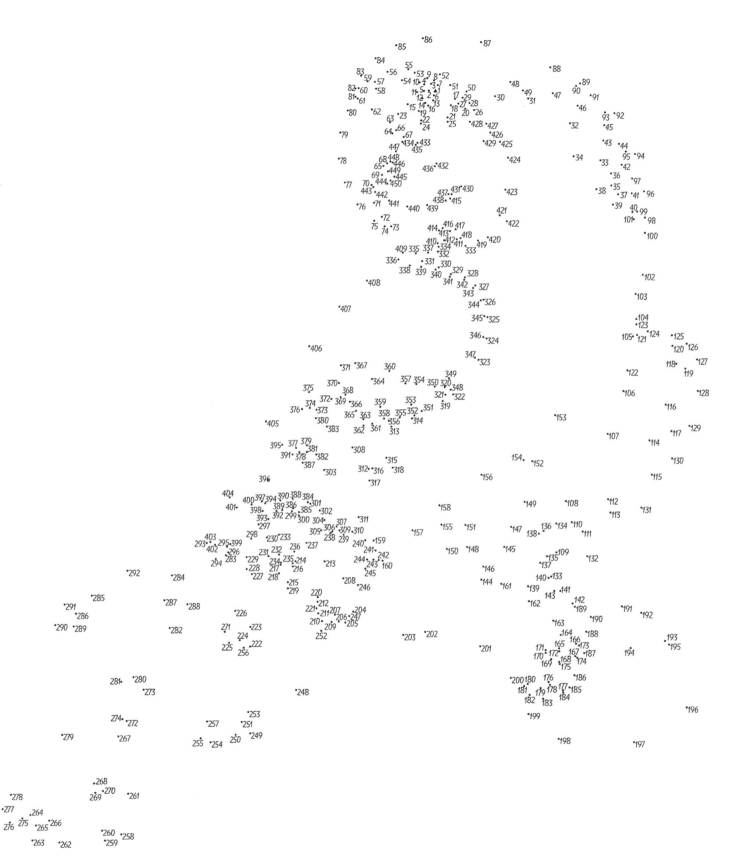

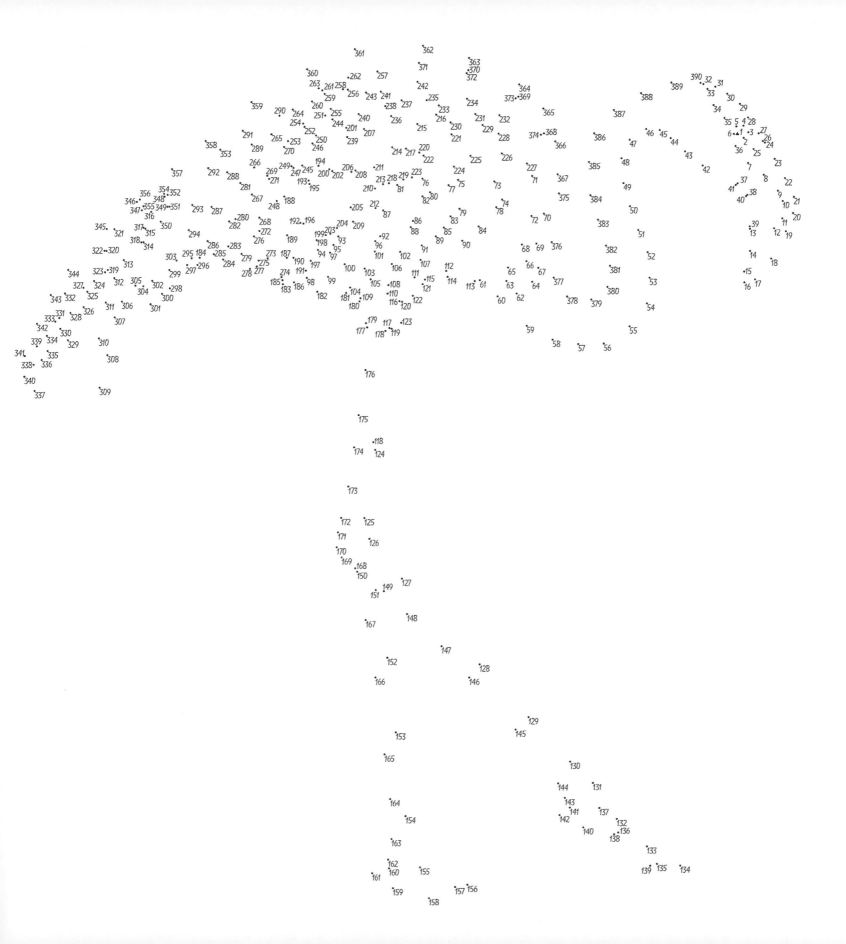

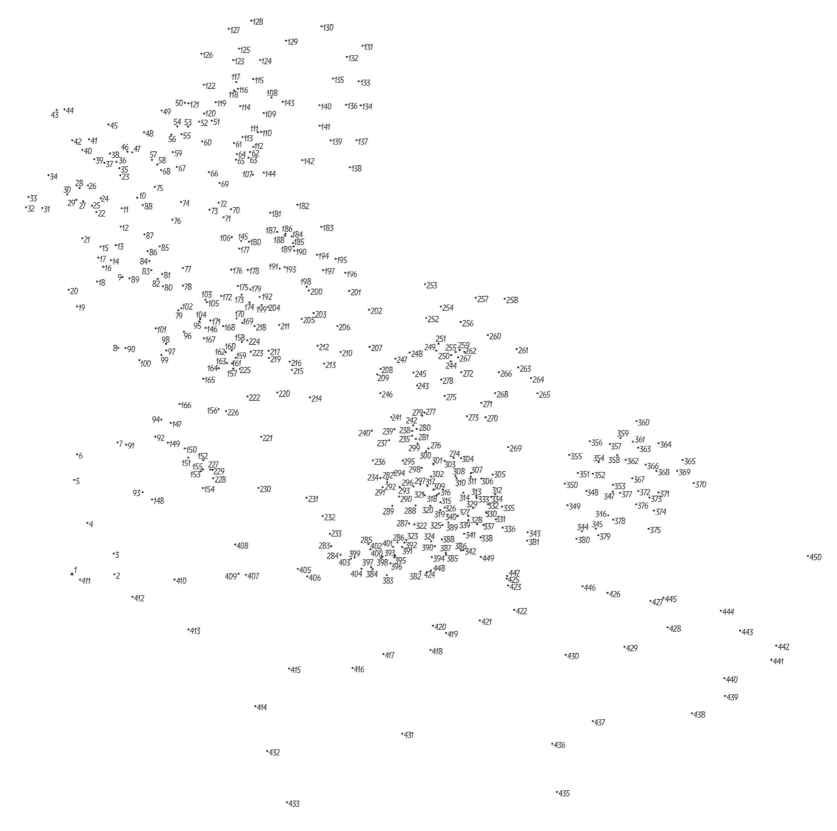

YOU HAVE BEEN
DRAWING

1.	Leopard	23.	Californian Surf
2.	Eagle	24.	Venus Flytrap
3.	Tornado	25.	Azure Window, Gozo
4.	Orangutan	26.	Tiger
5.	Jellyfish	27.	Halaveli, Maldives
6.	Camel	28.	Blue Whale
7.	Rock of Gibraltar	29.	Tuscany, Italy
8.	Chameleon	30.	Elephant
9.	Sunflower	31.	Mount Taranaki, New Zealand
10.	Koala	32.	Victoria Falls
11.	Mount Everest	33.	Seahorse
12.	Stag	34.	Electrical storm
13.	Hippopotamus	35.	Bear
14.	Niagara Falls	36.	Sloth
15.	Owl	37.	Hạ Long Bay, Thailand
16.	Panther	38.	Peacock
17.	Great White Shark	39.	Tarsier
18.	Dragon Blood Tree	40.	Tree Frog
19.	Parrot	41.	Komodo Dragon
20.	Flamingo	42.	Mount Kilimanjaro, Kenya
21.	Krakatoa Volcano	43.	Kangaroo
22.	Hummingbird	44.	Turtle

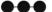